Debra Heimerdinger

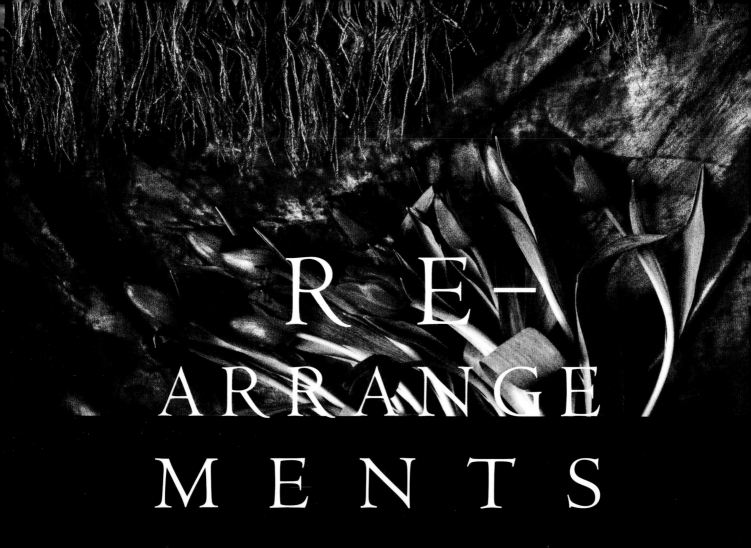

# RE-
# ARRANGE
# MENTS

## A Book of Flowers

DEBRA HEIMERDINGER COLETTE

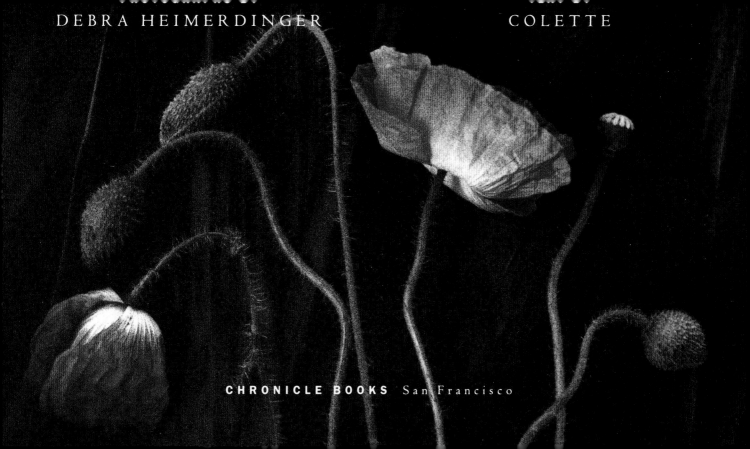

CHRONICLE BOOKS San Francisco

Wallflowers **FIGURES** INTIMATIONS

Remembrance    CONSTRUCTS

**Flowers mutely express what is not easily put into words.**

# INTRODUCTION

Depending on the circumstances, their use signifies a broad spectrum of
feelings—joy, grief, remorse, desire, love, sorrow, appreciation, and hope.
But the language of flowers aside, flowers themselves are as varied in effect as the uses they are put to.
Consider the delicacy of lilies of the valley and the drama of black tulips; the sensuality
of an orchid and the purity of a white rose; the mystery of opium poppies and the familiarity
of daisies. The form and color of flowers as well as the ways in which they are used
communicate specific messages. Beyond those aspects, there are the infinitely
varied associations we bring to flowers based on our own memories and experiences.
The scent of lilacs, for example, can call to mind the first, exquisite note of spring for one person
and for another be a sickly reminder of a tedious cousin's perfume.

**As subject matter, flowers are universally familiar.**

by DEBRA HEIMERDINGER

There is perhaps no other object so woven into the visual fabric of Western culture.
The flower as image is ingrained in every form of representation, running the gamut from high art
to prosaic decoration—from the precise individualism of seventeenth-century Dutch still-life paintings
to the rote stylization of a wallpaper pattern. I found that photographing flowers with originality
was a decided challenge. As an artist and curator, I spent time grappling with theories
of post-modern art. In the mid-eighties, I reached a point where I wanted to do something perverse:
I wanted to make beautiful photographs of an overused, clichéd subject—flowers.
That challenge is clear to me in retrospect, but at the time I began making photographs of flowers,
I was operating on a more instinctive level. The disorder and upheaval of two years of renovation
on my living space was reaching critical mass. My patience had run out. I needed a way
to transform the source of my discomfort into something positive. In the tradition of silk purse
from sow's ear and straw into gold, I set out to make my own transformations. I could not physically
change the disheveled state of half-finished rooms, but I could translate their disorder
into something more balanced by introducing the perfection of flowers
as a counterpoint to the chaos and then recording the results.

**The first photographs focused on the walls of my 1894 Victorian.**

The stripped walls revealed a patina of cracks and mottled areas colored by residues of aging glue and wallpaper dyes. Physically, the walls became the backdrops for the photographs, but metaphorically, they were time capsules revealing memories that stretched back a century. These first photographs, in which I worked specifically with the outer edges of the room and its architecture, are called W A L L F L O W E R S a title that plays on both the literal and the figurative. From the beginning I was interested in looking at flowers in non-traditional settings.

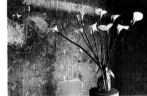

The first photograph that I made in this series, white callas in a mason jar, shows the flowers in a container and on a pedestal. That is the only image that portrays flowers in the traditional mode of "in something, on something." Because I was already working within the physical limits of a single room, I wanted the flowers to be free from vases and tabletops. In retrospect, that sense of freedom within order was something I needed myself, and it was my unconscious motivation for making these photographs.

Gradually, my attention focused on the form of particular flowers. The second series, F I G U R E S isolates flowers against white backgrounds, much like nineteenth-century

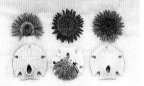

botanical illustrations. There are few additional objects in these pictures to suggest associations beyond the form and presentation of the flowers. The effect is to stress the interaction of each flower's shape, texture, and color.

The third and fourth sets of photographs, I N T I M A T I O N S and *Remembrance,* are based on associations and are intended to be metaphorical. The photographs in *Intimations* are dark and somber. Despite the allusion to Wordsworth's "Intimations of Immortality," these are images of endings and death. The ephemeral nature of flowers suggested metaphor, but events that took place while I was working on this series helped to define it in more concrete terms.

The photograph of tightly furled blue iris buds lined up on a black background was made at the time of the Gulf War in 1991, and I see it as a reference to the war's missiles.

The picture of long-stemmed red roses stripped of their leaves and resting on the black ice of a North Carolina pond was one of two photographs made outside of my house. Later, when I visited the national

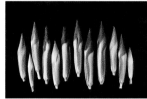 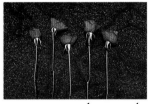

monuments in Washington, this picture became for me a metaphor for the Vietnam Memorial. The photographs in R E M E M B R A N C E are bittersweet. They are about memory as an extension from past to present; they are about loss and preservation. Some of these images are memory shrines. For example, a grandfather's paint box, a photograph of a great-aunt as a girl, and a grandmother's favorite flowers combine to become a visual genealogy chart.

The last series, C O N S T R U C T S is an extension of *Figures* in that it is more about form and arrangement than association. But these later images are more varied in their colors and backgrounds and, in some cases, more abstract. For example, a calla lily in a brown paper bag is partly camouflaged by a wall that seems, at first, to be part of the bag. The illusion challenges initial perception. Just as a photograph can suggest something as literary as a metaphor, literature can convey pictures. While almost every writer is compelled at some point to allude to flowers, some, including Rainer Maria Rilke, William Carlos Williams, Wallace Stevens, and the French author Colette have used flowers as subjects in their work. I found Colette's writing particularly appealing in connection with my images. Her descriptions are layered with rich personal associations and sensual responses to flowers; she depicts flowers both as physical objects and as symbols. Her words create a palpable atmosphere filled with the scent, shape, and texture of flowers and redolent of the accumulated memories and relationships of a uniquely creative life. Both the words and pictures in this book reveal a fascination with the allure of flowers— their color and form as well as the associations and metaphors they suggest. As enduring subjects, flowers are exquisite objects, emblems of passage, and keys that unlock personal and cultural memory.

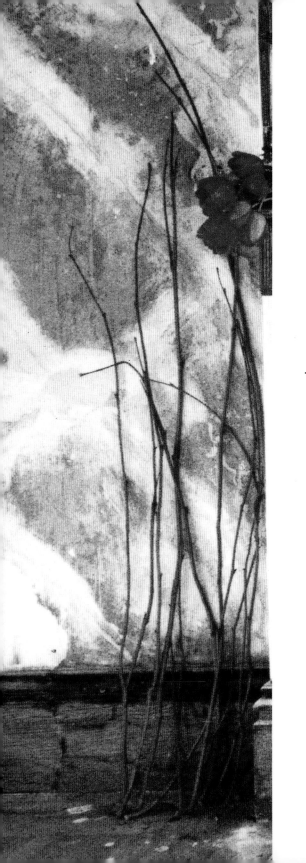

WALLFL

# OWERS

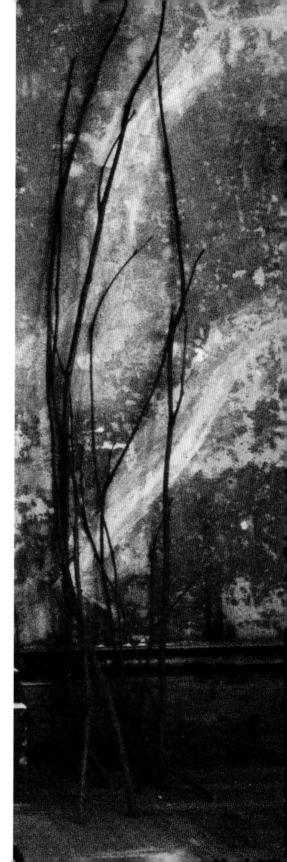

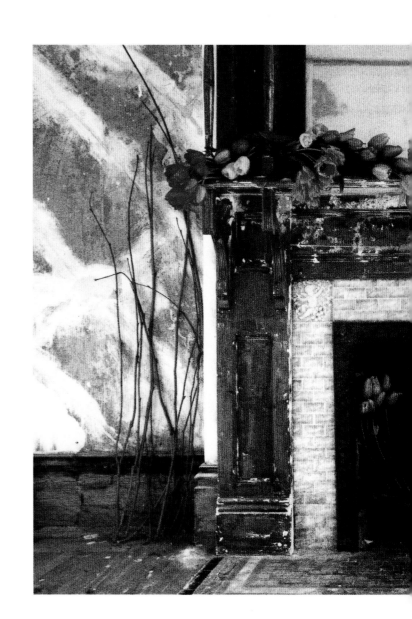

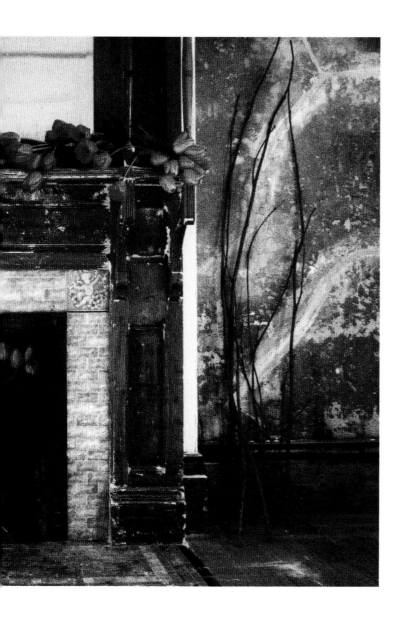

My choice
does
not
mean that,
once
assembled,
the
flowers
I have
named
will please
the
eye.

And
besides,
I've
forgotten
some.

But
there's
no
rush.

I am
heeling
them
in,
some in
my
memory,
others
in my
imagination.

Where,
by the
grace of
God,
they
still find
the
rich soil,
the
slightly
bitter waters,
the
warmth
and
the
gratitude
that will
perhaps
keep them
from
dying.

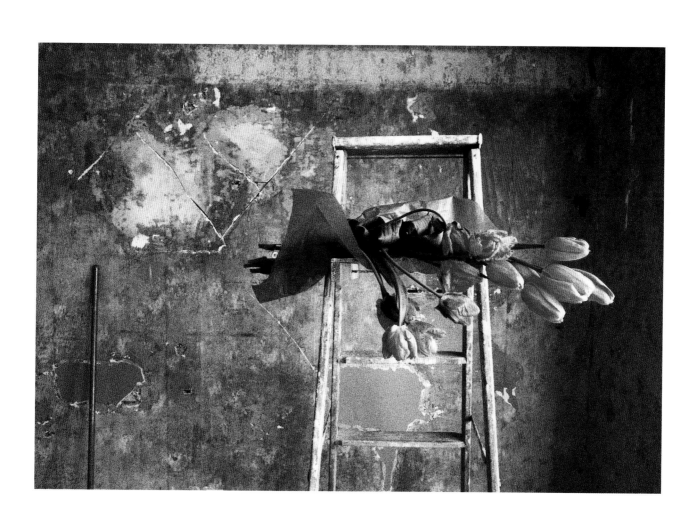

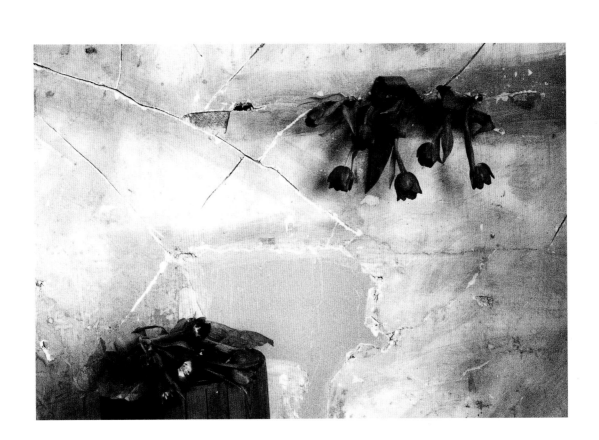

Neither
the flower
nor its influence
can be explained.

The rasping sound of a very real existence, a very real exigency, the thrust of the bud, the twitching erection of a bloodless stem just given its liquid nourishment . . . these are the spectacles and the music I came to respect more and more as my curiosity grew. Is this to say that I handle the feelings, the sufferings of plants with kid gloves, out of scrupulousness or compassion; that I fret over cutting into the fiber, lopping off the head, or drying up the sap?                    No.

Deeper love does not mean greater pity.

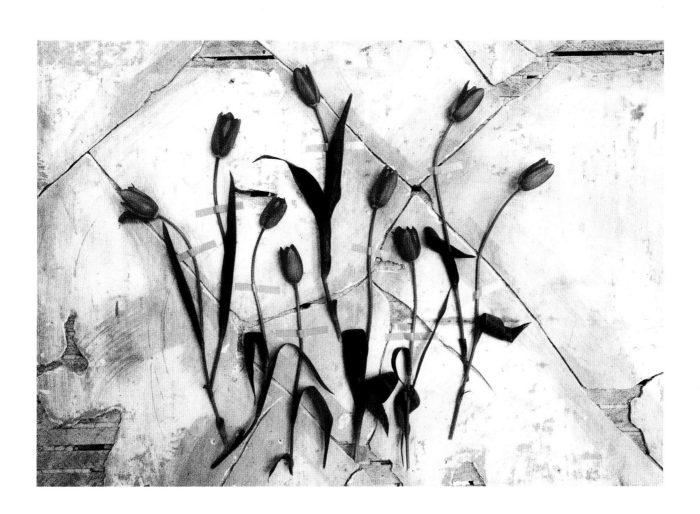

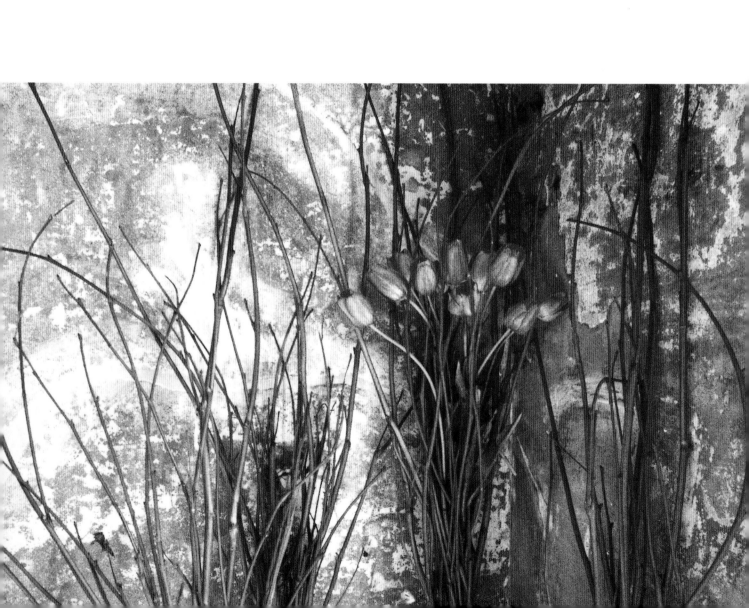

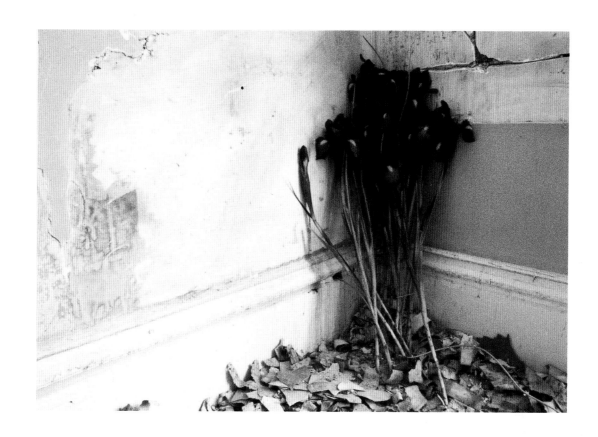

For those of us
with white blooms,
charged with
the task
of troubling
human beings,
midday is
a treachery
we never
tire of.

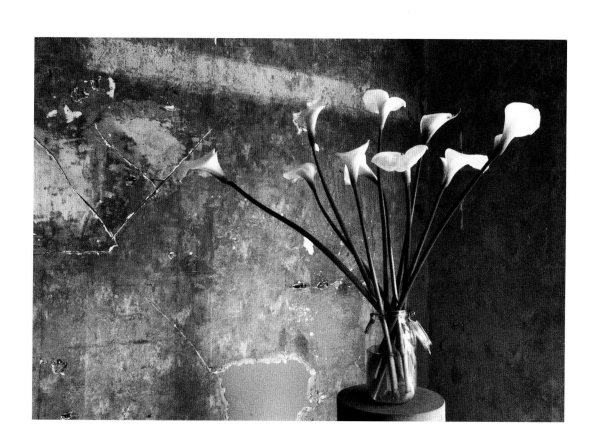

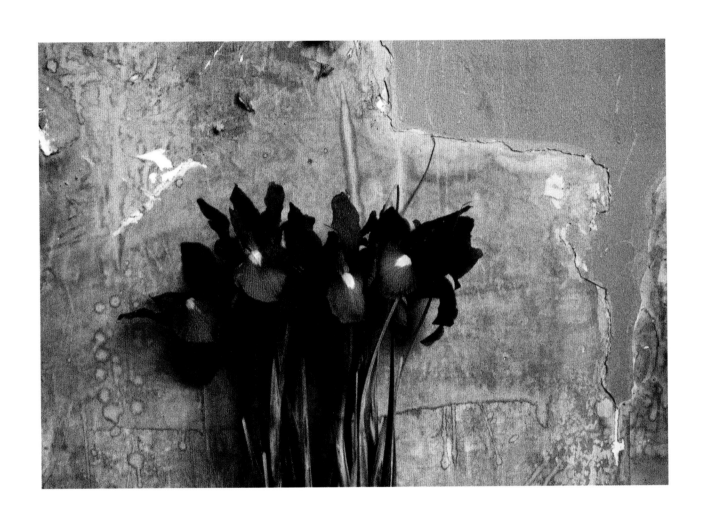

I can recall an extraordinary profusion of irises in May...
Thousands upon thousands of irises, a mass of azure bordering on a mass of yellow, a velvety blue-violet confronted with a pale, pale mauve, black irises the color of spiderwebs, white irises with the sweet smell of iris, irises blue as a nocturnal storm,

and

Japanese irises with long tongues.

To them,
to these imprisoned flowers,
I dedicate a portion
of that pity
that goes out
to caged animals.

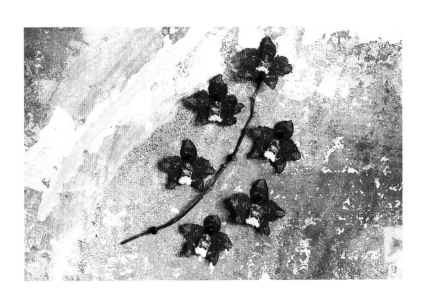

The  P E O N Y  has the privilege

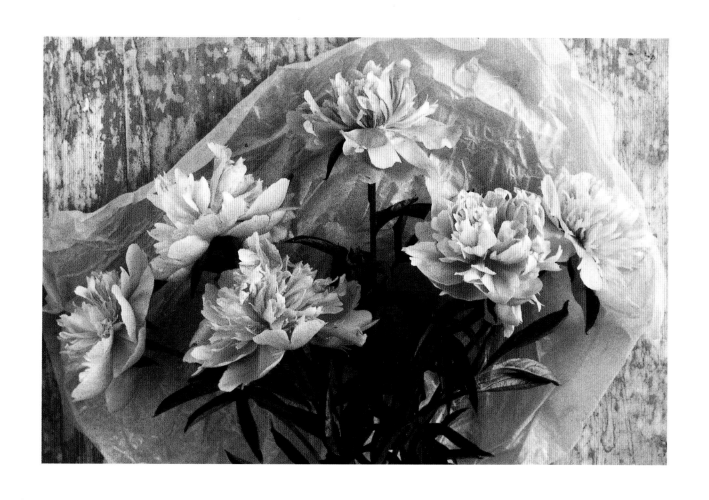

of putting us in touch with the true S P R I N G ,

bearer of many suspect odors,

the sum of which is likely to leave us

E N C H A N T E D .

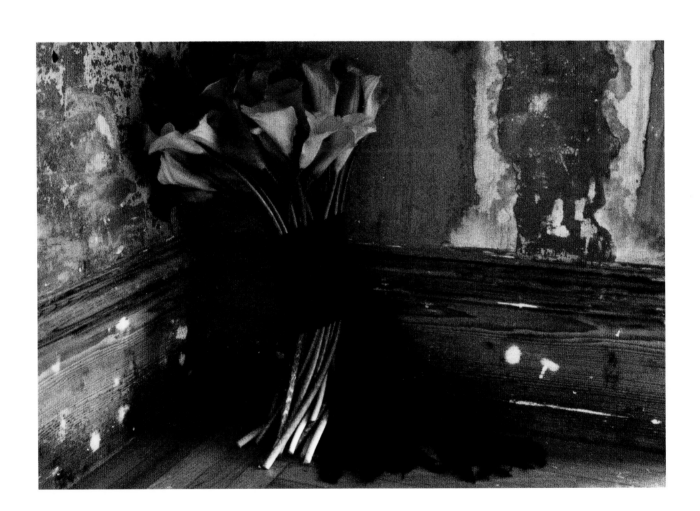

They bloom without respite

    even as they suffer,

and, with their long, canine tongues

        hang i n g   o u t —

look at the medial nervure,

    the multiple canals,

the fleshy and transparent edge —

       seem to pant.

    It is their own perfume

      suffocating them,

    so sweet is it,

        linger i n g ,

     made for

      crawl i n g . . .

F I G U R E S

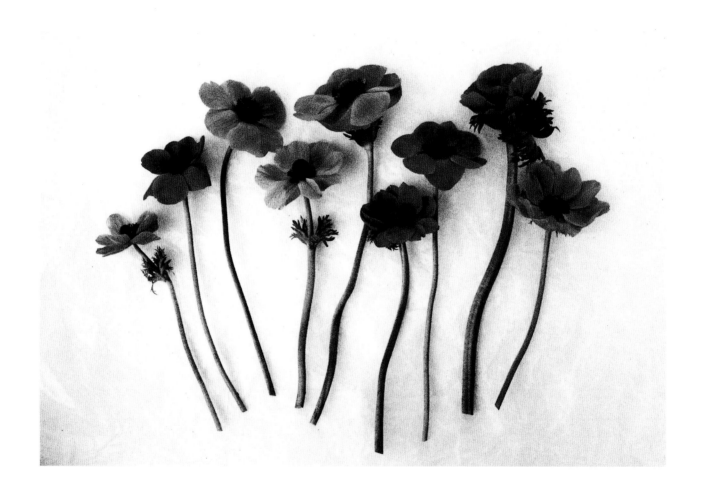

There are connoisseurs of blue just as there are lovers of wine.

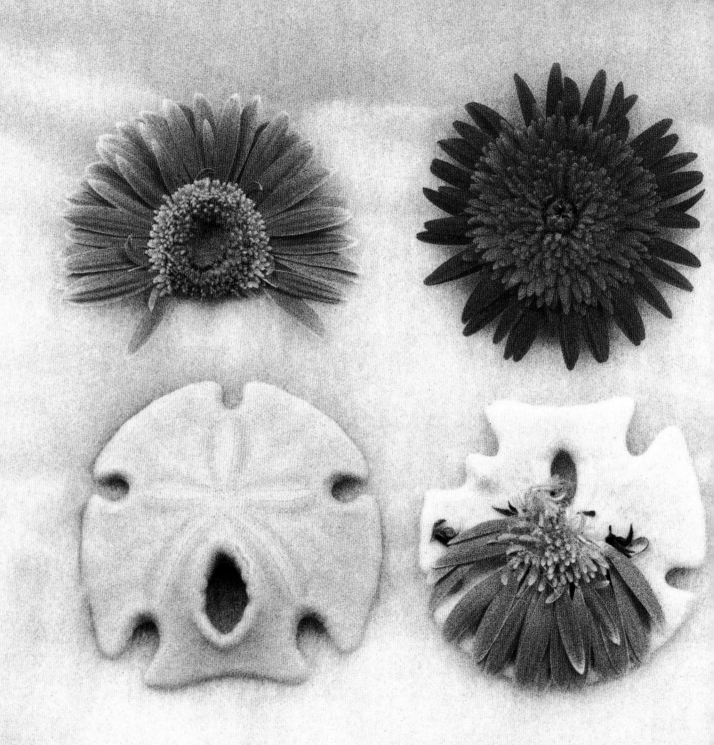

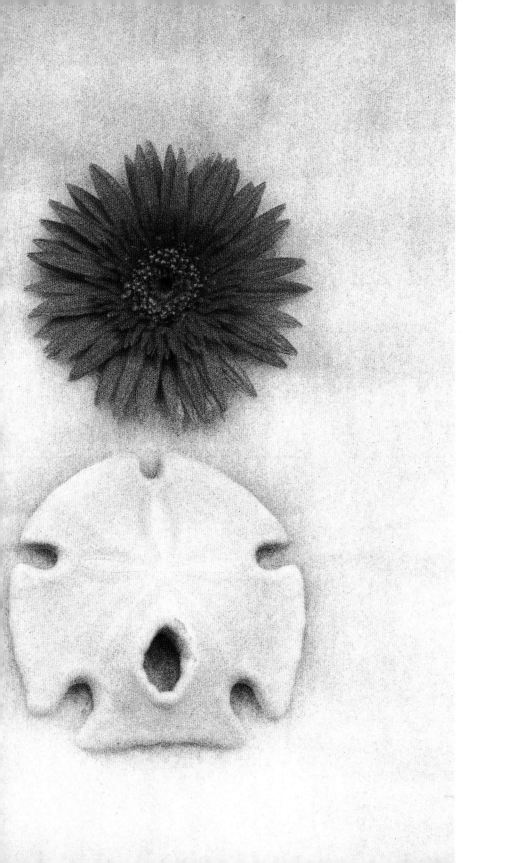

And it avails

another floral sprite of the funereal swamps

nothing at all

to appear

in the guise

of a pale-pink fairy,

all got up in gauzy linen.

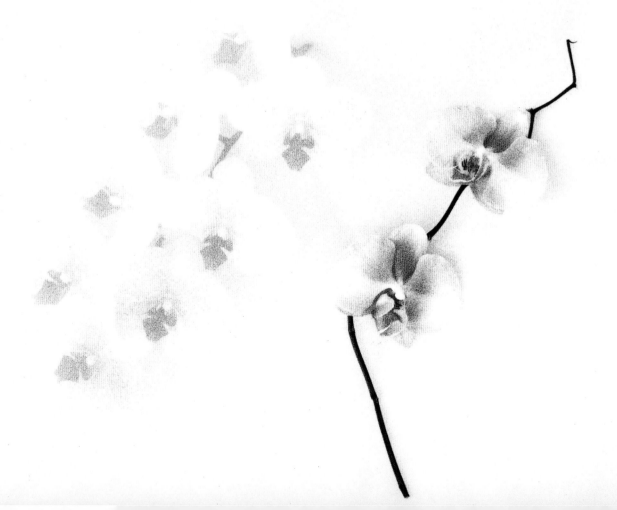

And what of the pale promises of

scarlet,

pink,

and

purple

made to me

even as they swooned?

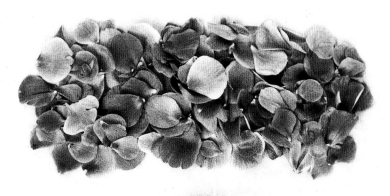

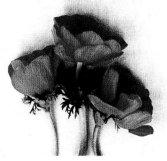

...all is permitted
**the rose**—
splendor,
a conspiracy of perfumes,
petalous flesh that
tempts the nose,
the lips, the teeth.

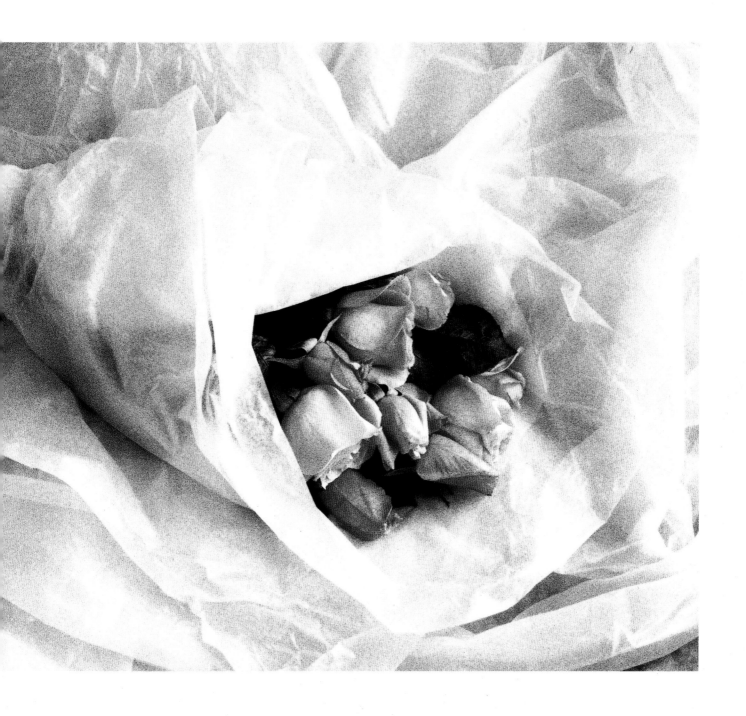

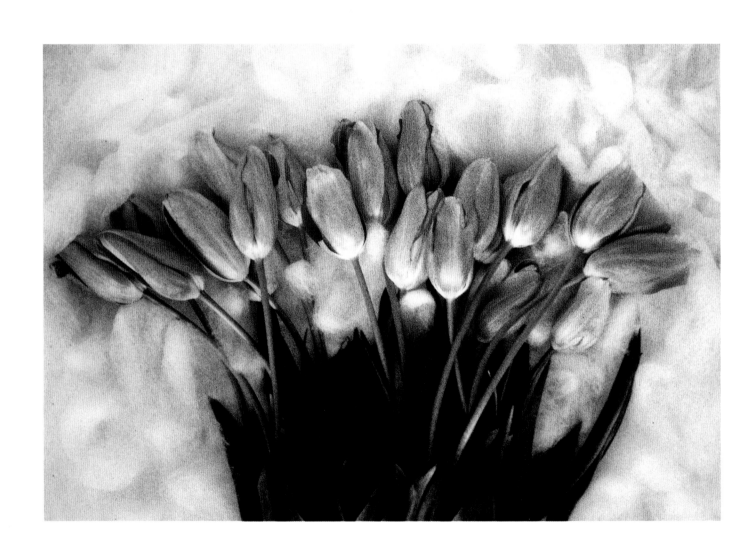

At Cours-la-Reine,              when the

between                         last trucks

one and                         had reached

one-thirty                      their

in the                          canteens,

afternoon,                      those

who loved

flowers and silence

could savor

a strange respite,

a solitude

in which

the flowers seemed

to recover

from

human curiosity.

Where is the majesty

in that which is ending,

alongside the unsteady departures,

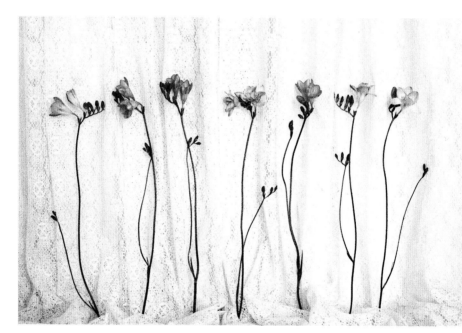

the disorders of dawn?

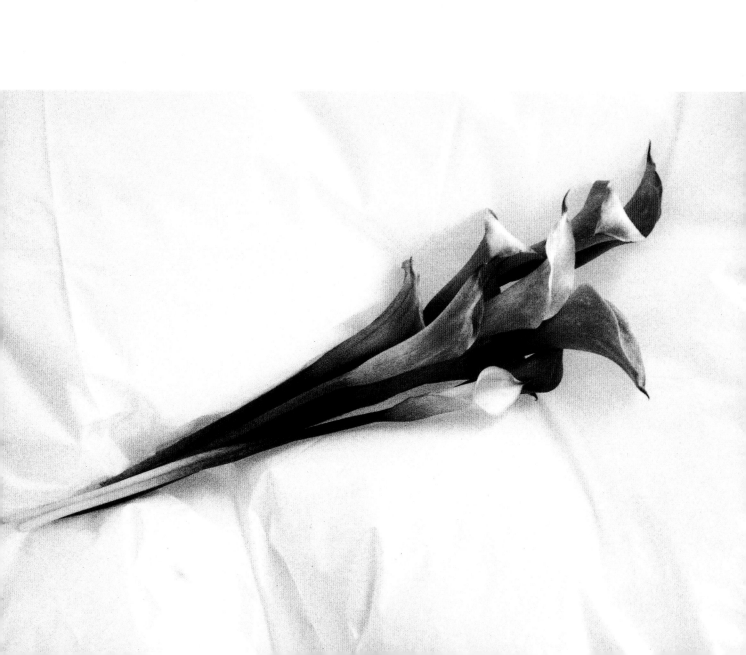

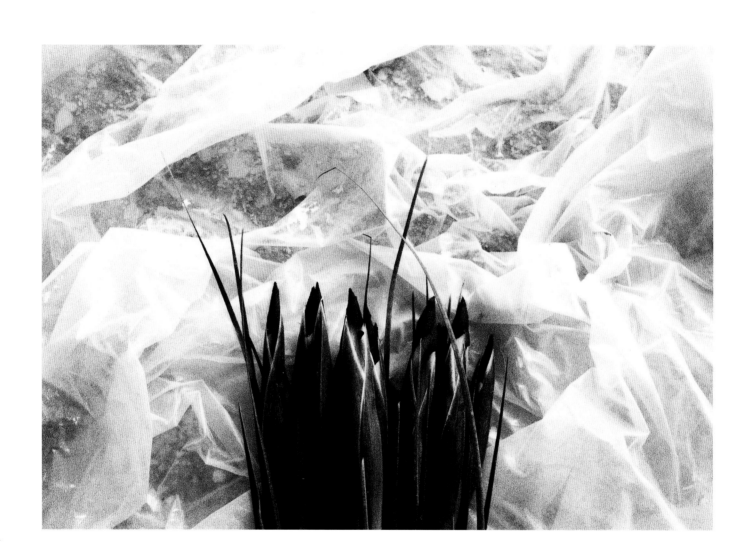

I hear the iris   u n f u r l.
Its last protective layer of silk rasps
and splits along an azure finger,

itself unrolled just a short time ago,
and sitting alone in

a quiet little room,

one might be startled if one
has forgotten that on a

nearby pier table

an iris has suddenly decided to bloom.

To lie about
a creature's rhythm
is very near to
lying about its essence.

I have experienced
the anguish and the joy
of perceiving life
in the plant kingdom
not at the movies
but through my feeble
though complete senses,
each shored up
by the other.

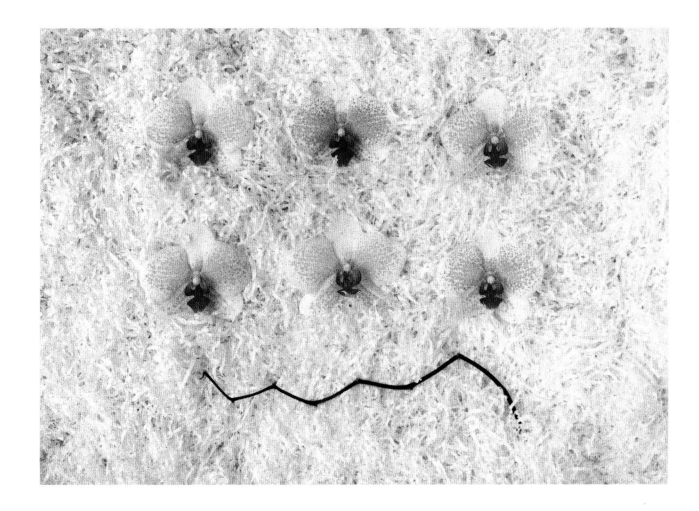

INTIM

ATIONS

All of us wince when

                  a rose,

   falling apart in a tepid room,

               lets   go  of

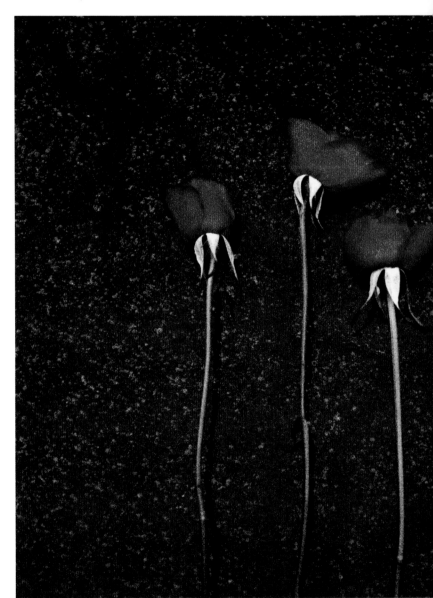

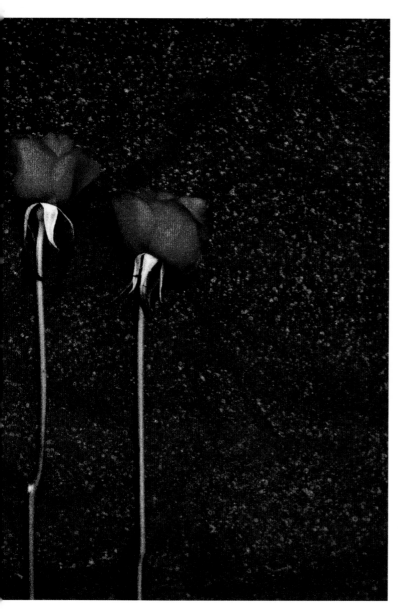

one  of  its
        shell-like    petals
                and sends it

        adrift

      into its own
reflection

    on a smooth marble surface.

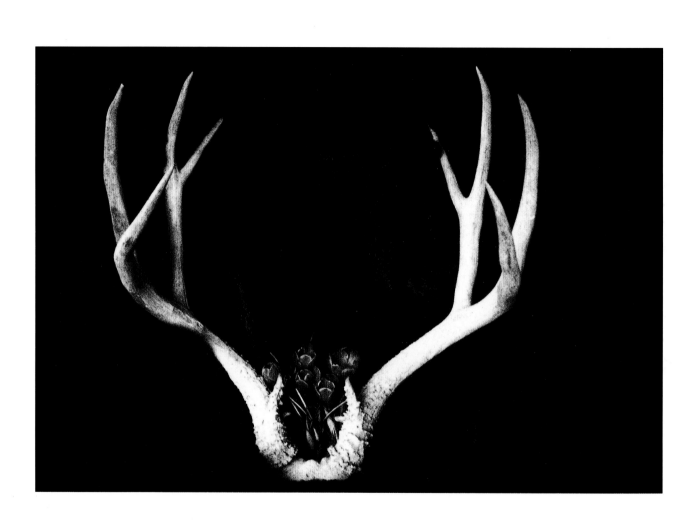

To say ephemeral is not enough.

Born of the morning,
this wondrous flower has already begun to die.

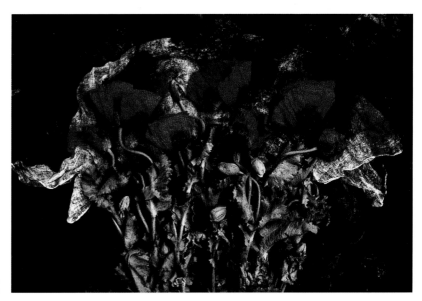

I will not
leave its side before its final gasp.

The secrets of plants, their magic defenses fall **one**

**by**

**one.**

Their traps work in the open and reveal

the

carnivorous

instinct,

the

taste

for

murder.

The glossy edges, rounded into the lip of a lidded chalice,

are

deadly.

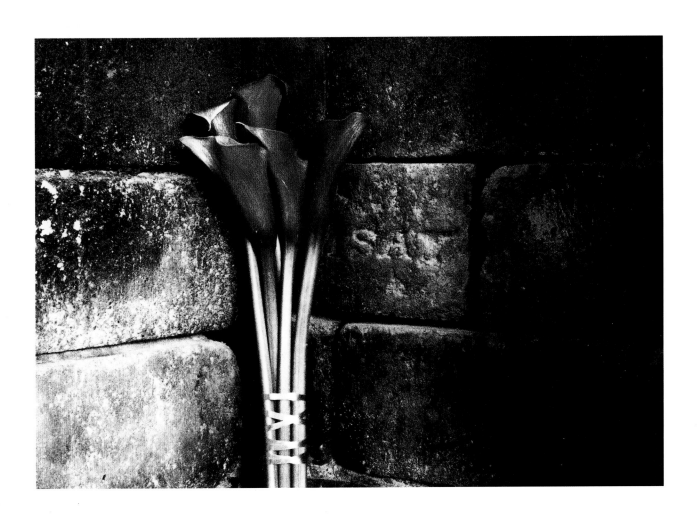

The asymmetrical iris hesitates, then splits

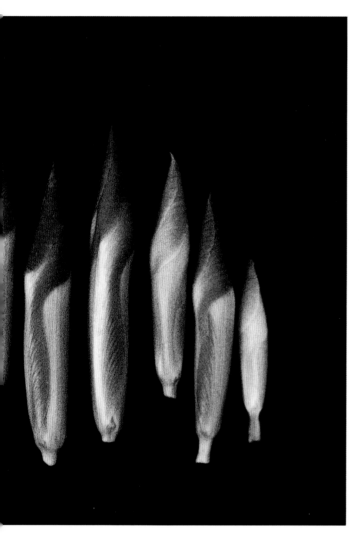

its silk cover with an uneven tongue.

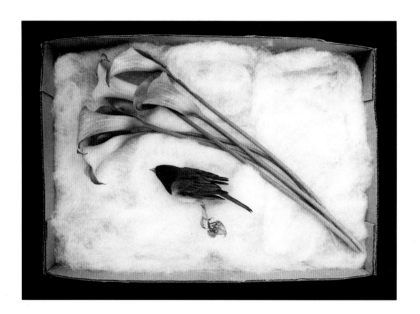

Uneasiness, qualms, the certainty henceforth of inflicting a real death with every step, the greatest anxiety.                    remorse at seeing that which

we hold to our breast, to our lips,

that which we most cherish,

falter and succumb at our own hands.

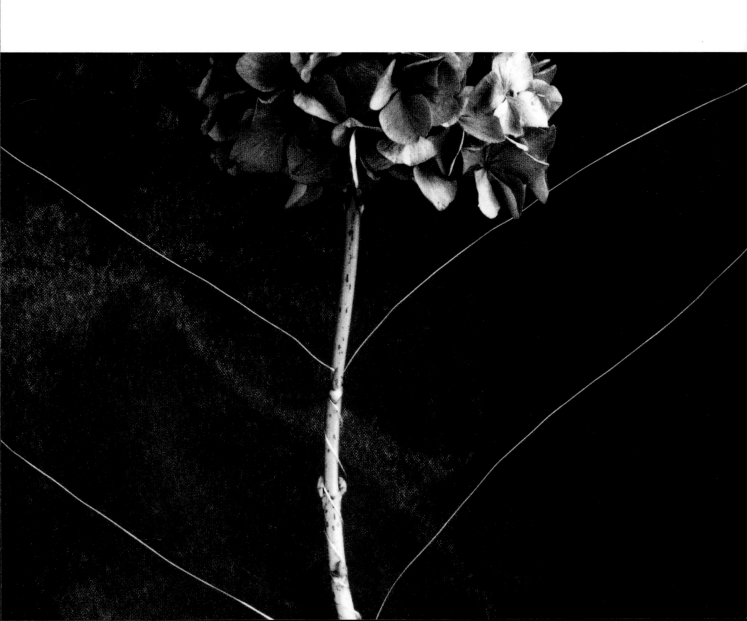

# The orchid,

whose spell is more powerful than that of any other game, had plunged him forever into those regions where a man, caught between two dangers, never fails to choose the greater.

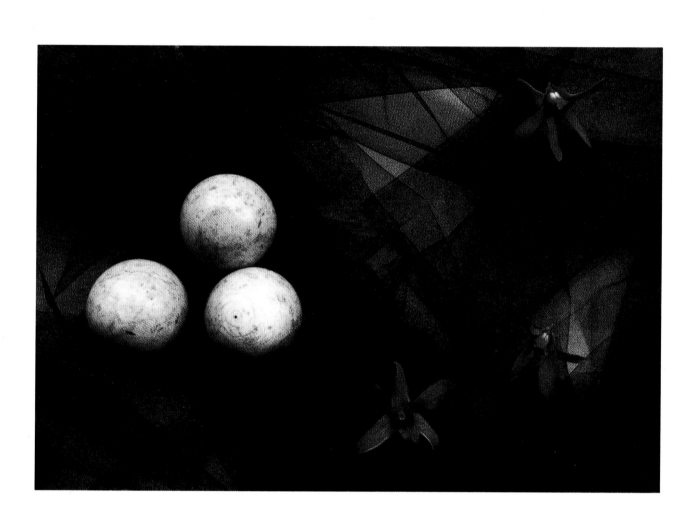

As I watched,
I learned
that its overwhelming
beauty
served a
murderous
strength.

I learned how
it covers,
strangles,
adorns,
ruins,
and
shores up.

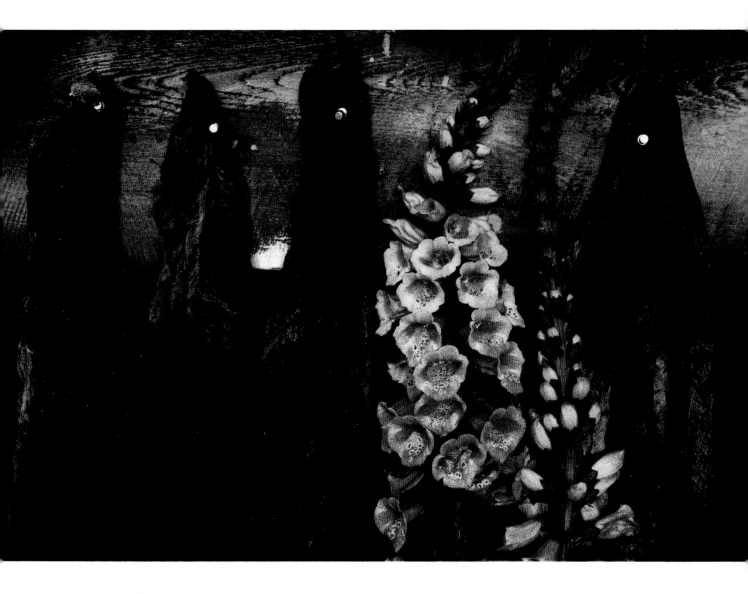

When the sun strikes it, it is imbued

with a dusting of constellations,

revealing the fact that the reigning

principle behind so much blackness

is a blue, no, purple, no, blue so

substantial that it wins our admiration.

"It's like velvet!..."                                      And then?

And then nothing.

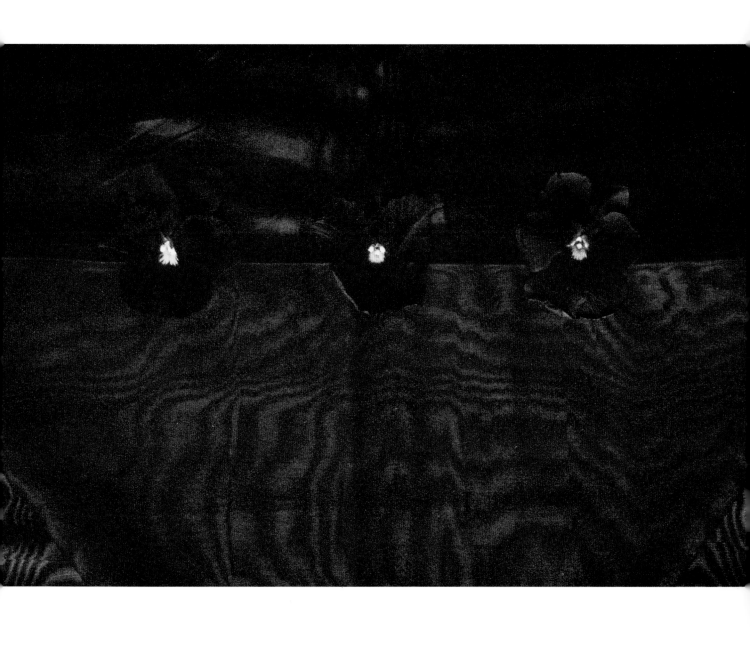

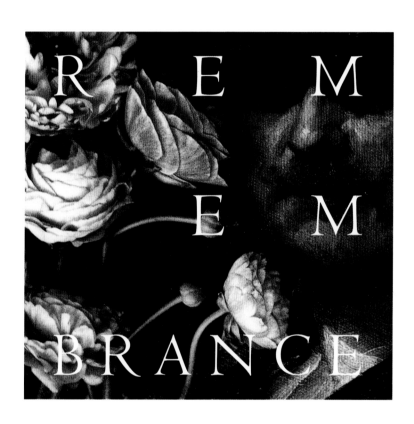

So many charms

persist on this land some would call stripped!

Later . . .

it will have everything

that might enchant

and hold,

everything that disdains

and  turns away

from the inconstancy and heedlessness

of man

who abandons the earth

as he does a mistress

cherished for her beauty alone,

at the moment he fears

she might be

losing it.

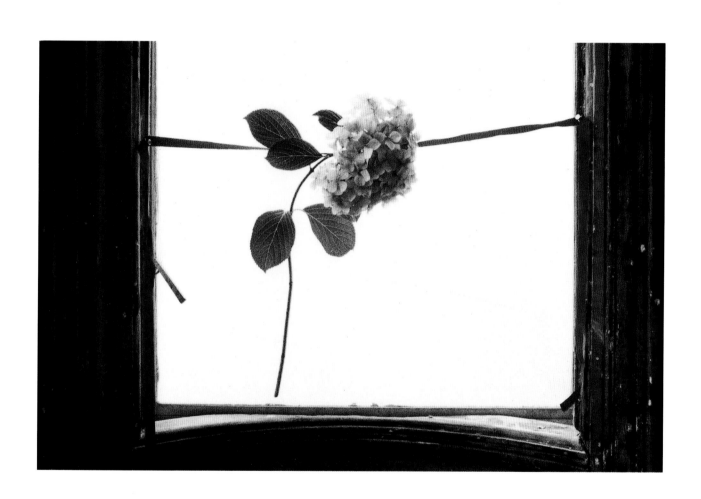

It raises itself above the dry leaves at

rains fall, heavy drops

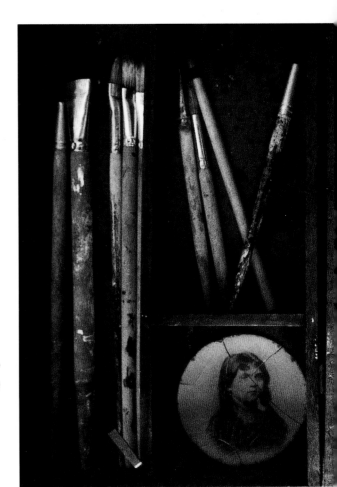

arabesques escaping

and the first notes, of a luminous spher

that time of year when the first warm

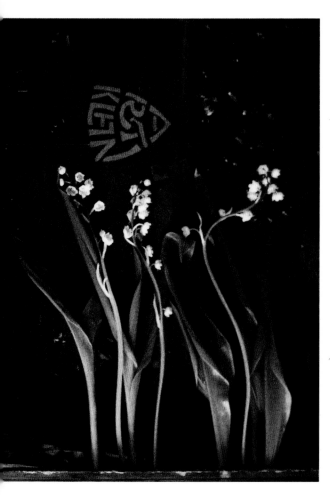

that free the simple

the blackbird's beak,

city, springing from the first nightingales.

By poring over
an image
in memory,
I sometimes
succeed

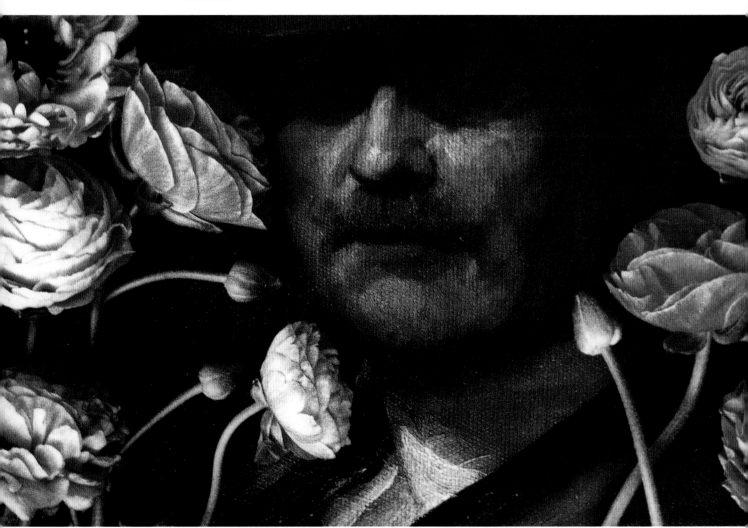

in re-creating
a flower
that
intrigued me
in the
past.

The plant world
is not mute,
though the sound
of its activity
reaches us

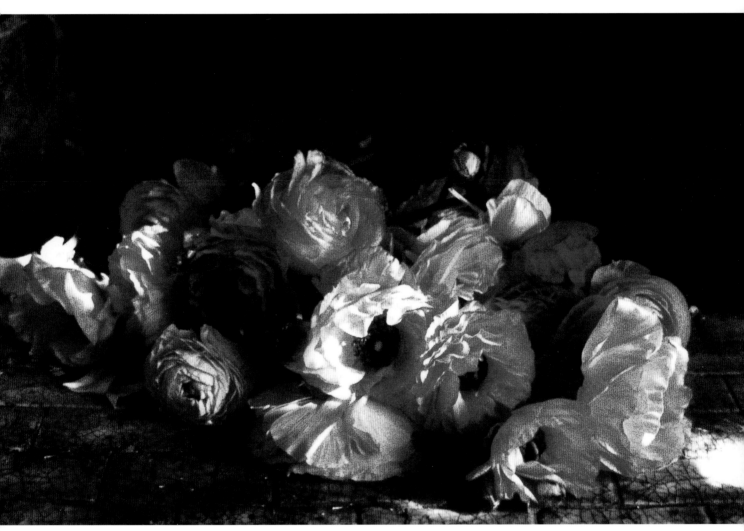

only by chance,
as an exception,
as a subtle recompense
accorded
either our vigilance
or our laziness.

The shop was resplendent with those roses that have lips, cheeks, breasts, navels, flesh glistening with an indescribable frost; roses that travel by a i r, stand e r e c t on the end of a disdainful stem, and smell of peaches, tea, and even of roses.

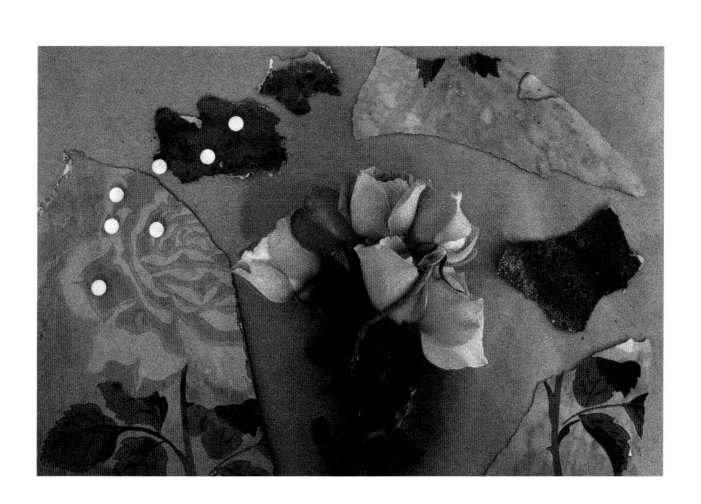

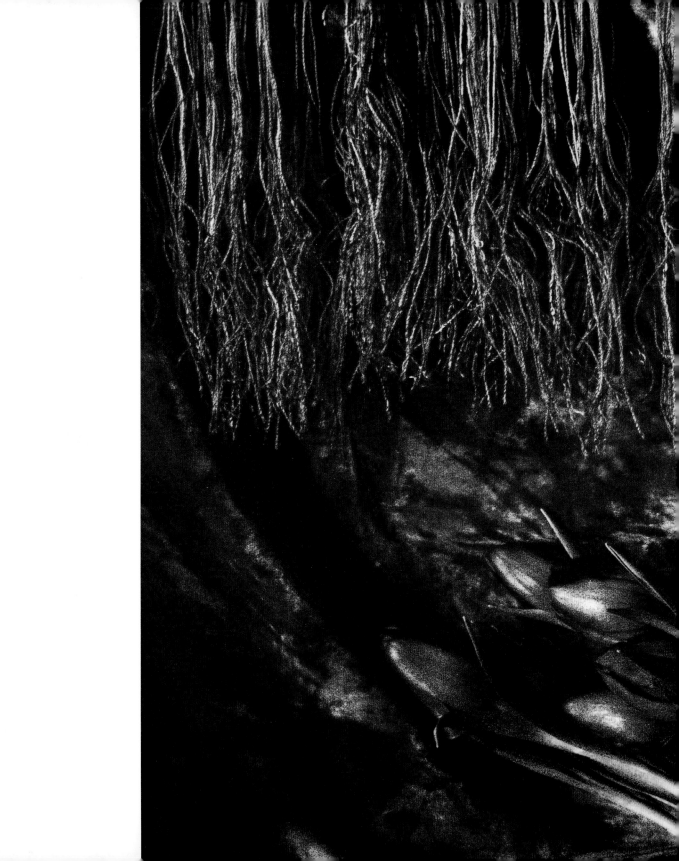

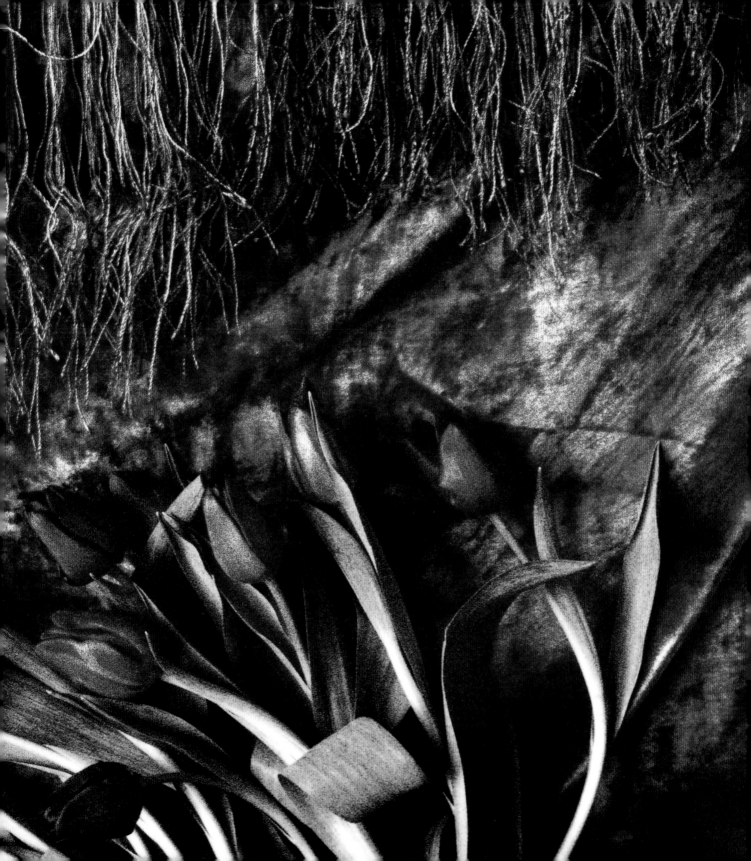

**Between bud and bloom there takes**

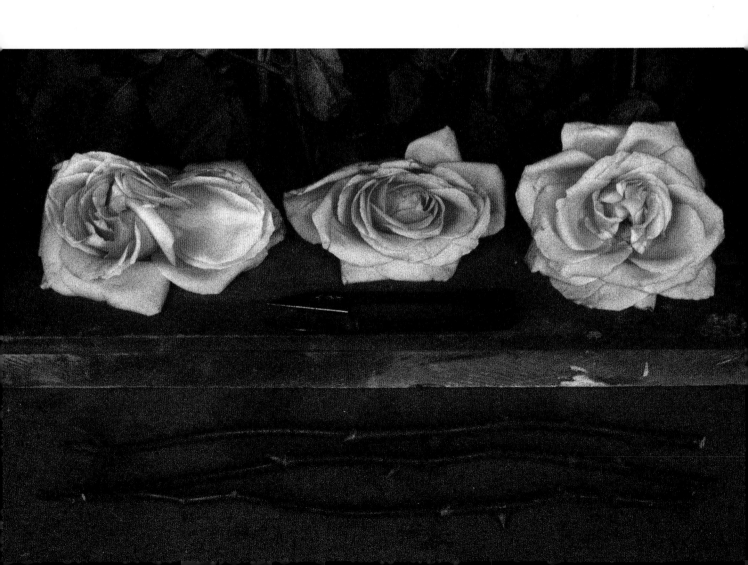

lace a miracle of effort,                                then of efflorescence.

Garnet red,

bright pink,

sentimental pink,

and three

or four

other carmine reds,
they are the colors of good health

and will delight me

throughout

the coming week.

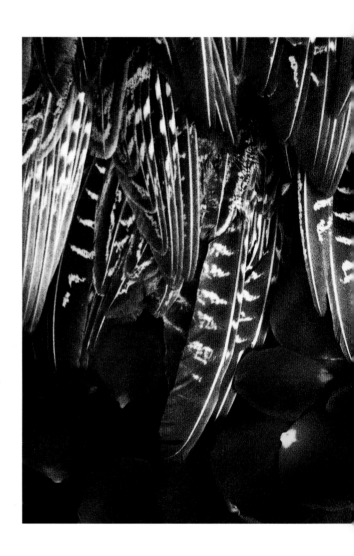

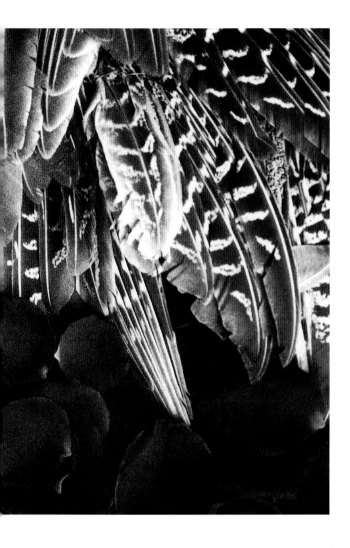

And then, all at once,

they will drop
**their brazier of petals with a floral sigh**

imitating

the sudden demise

of the rose.

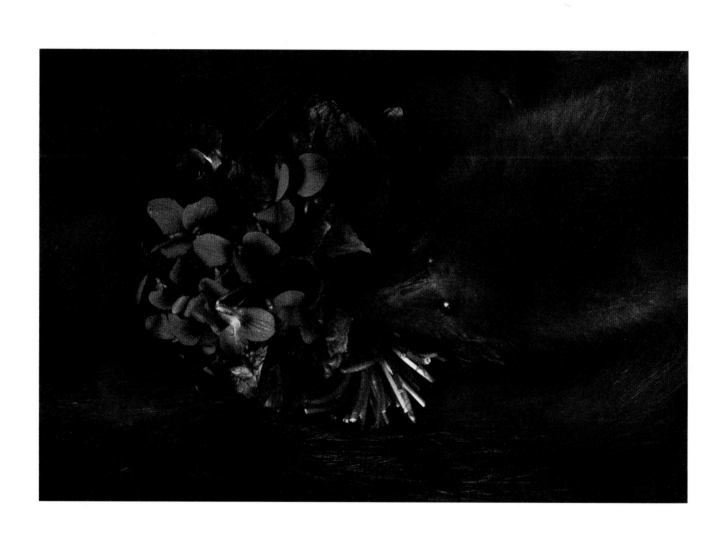

An almanac religion connects us to a flower,
even a puny one,

when it symbolizes a season,
to its color

when it commemorates a saint,
to its scent

if it painfully takes us back
to a lost bliss.

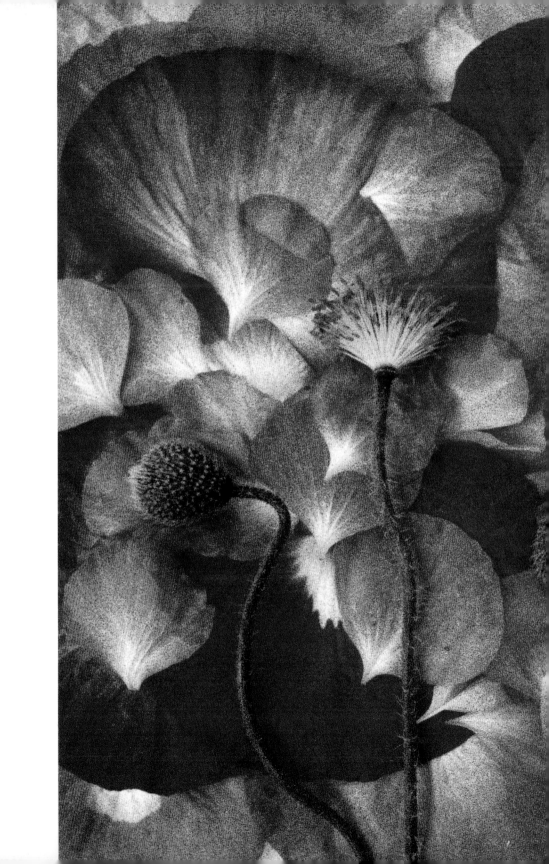

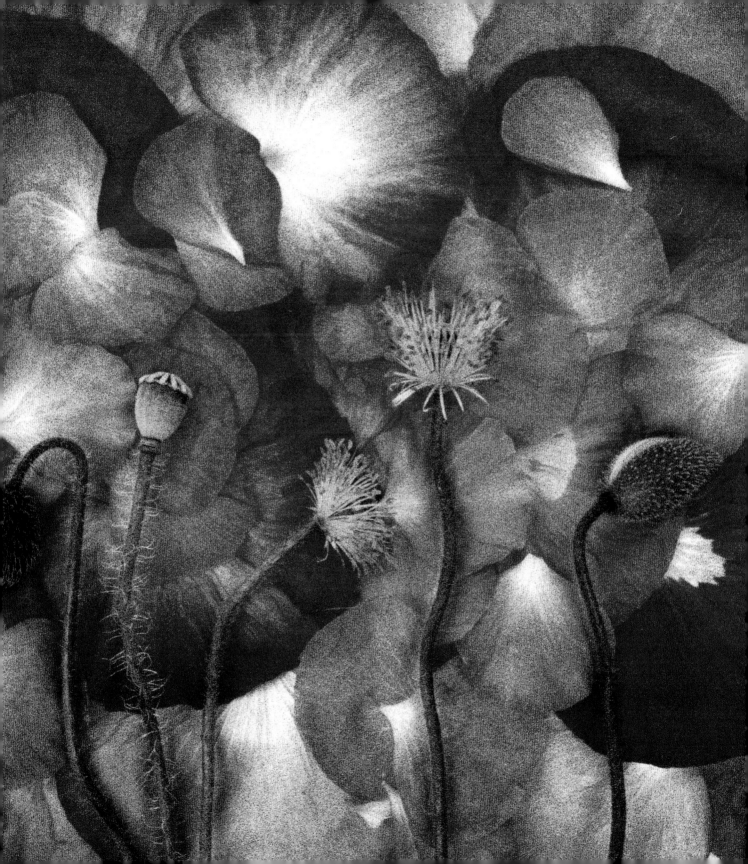

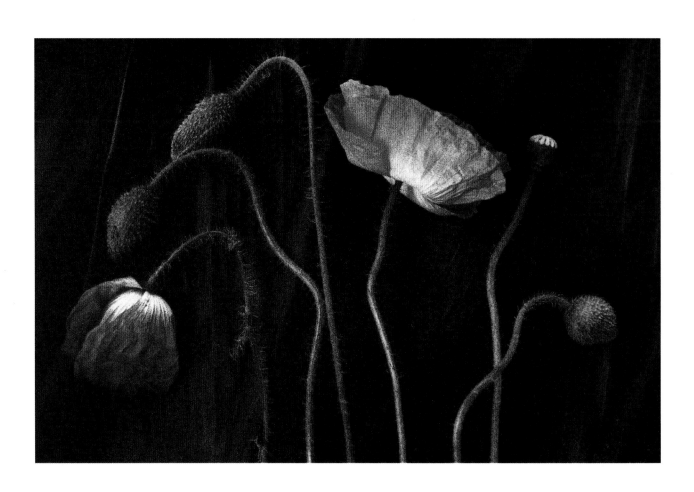

I left the big poppy, with its blue pollen and its slowly unfolding silk, to the fields and gardens.

Long afterward,
I came upon it again,
in Paris,
behind
closed doors.

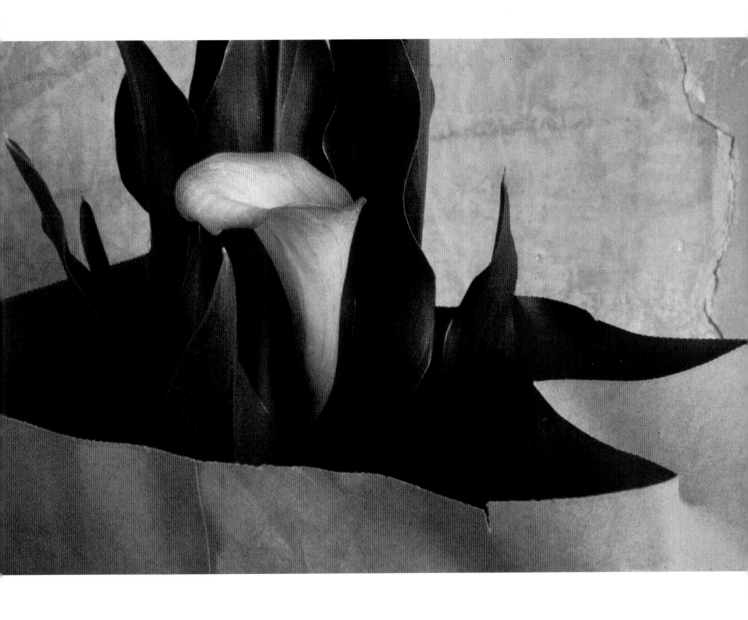

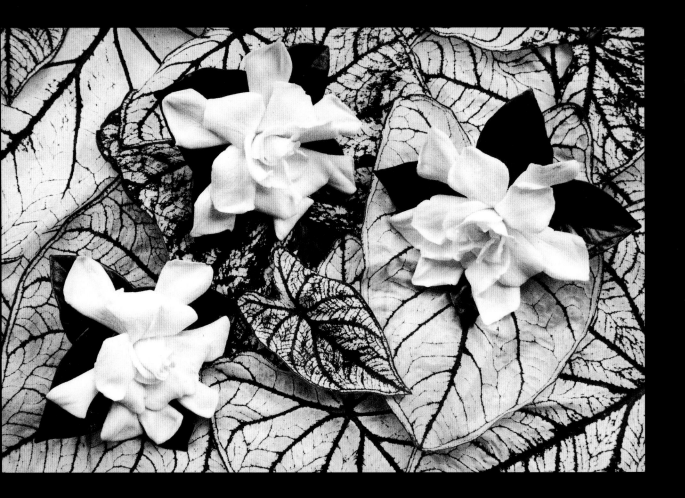

Innocent girls, ignorant girls, absentminded girls in love break off one of our flowered stems with their nails and fasten it, all cold and with no more expression than a buttercup, in their hair or at their waists. There I sleep scentless. But at the appointed hour—"six o'clock!"—I let out my feverish, mute discourse.

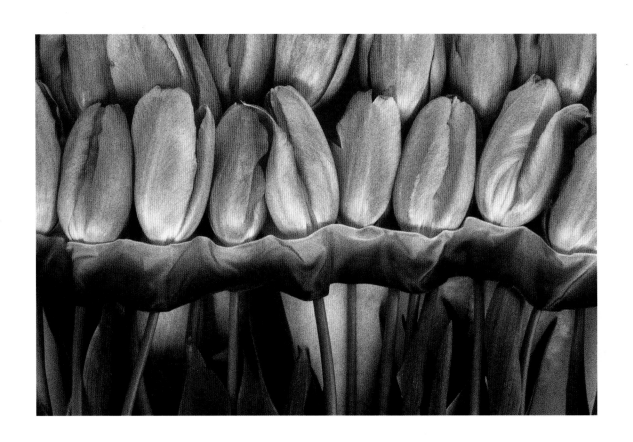

But in the strange,

digitate shape of its bloom,

I read the exact pose

of a Siamese hand,

with the tips of thumb

and forefinger touching,

the other fingers

standing straight up,

aggressive.

In the language

of the Siamese ballet,

this stiffening

of the hand

at the end of a dancer's long,

supple arm serves,

as might a letter of the alphabet,

to express anger.

Which was the first to imitate the other, the roused hand or the rebellious flower?

All this comes back to me as I write,
all this that flowered long ago,

those curves,

that softness of design,

the primness and the habits.

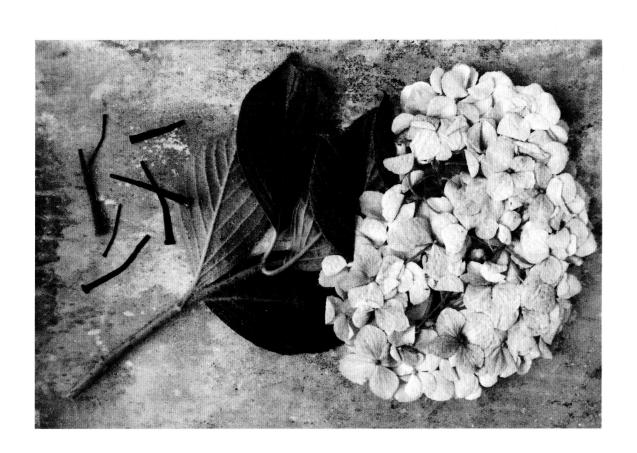

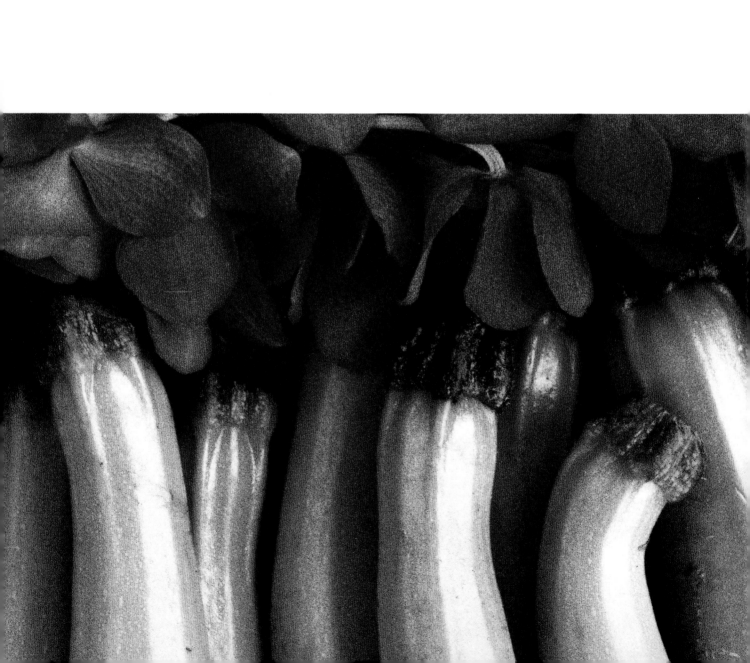

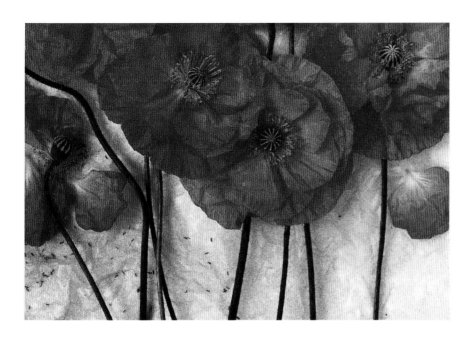

But to those who love the smell of opium and choose not to smoke fall various pleasures:
hour after hour
fragrant with
tea and tobacco,
the occasional touch
of a bit of silk
or a priceless rug,

an unforeseen
friendship,
and the aegis,
which is all it takes to turn the night crimson,
of the majestic
scarlet poppy.

**The sound of** wing cases opening,

**the sound of** tiny insect feet,

**the sound of** dead leaves dancing was

        irises, in the soft, conducive light,

        loosening the dry membrane

        rolled up at the base of their calices,

**irises opening by the thousands.**

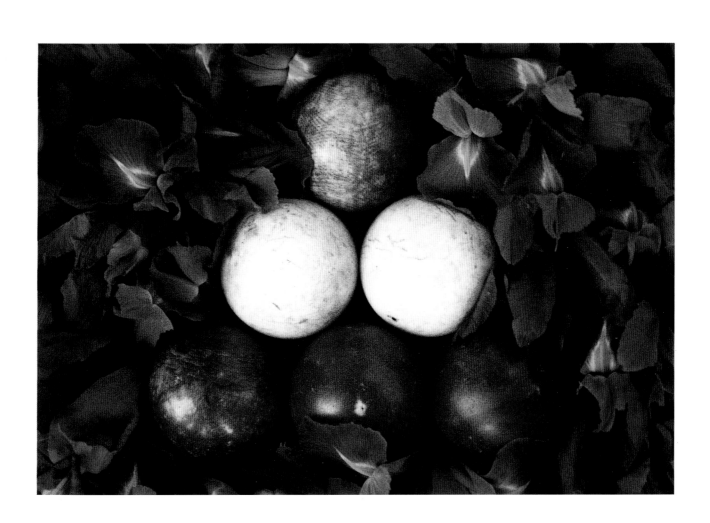

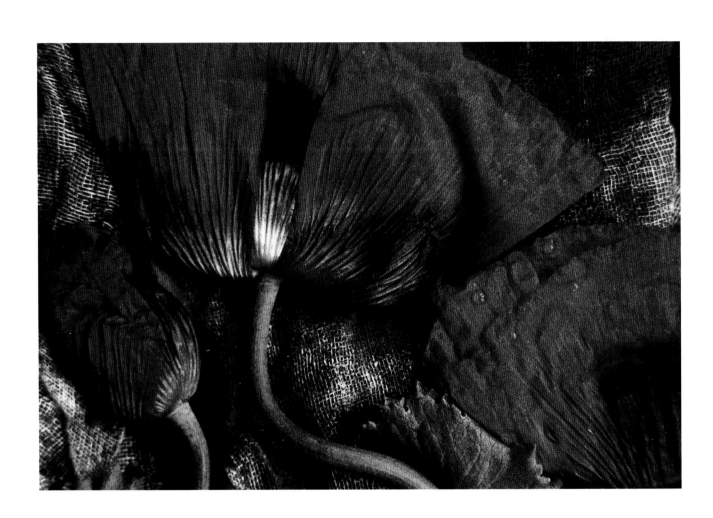

# I have enlarged

it in my memory,

I would depict it

with fire and without hope

as one does a lover

perfected in death.

Book and cover design:
T E N A Z A S   D E S I G N   San Francisco

Printed in Hong Kong.

Library of Congress
Cataloging in Publication Data

Heimerdinger, Debra.
     Re-arrangements: a book of flowers/
photographs by Debra Heimerdinger:
text by Colette.
            p. cm.
     "Text from Flowers and fruit by Colette"
     —T.p.verso.
     ISBN 0-8118-0267-1
     1. Photography of plants.
     2. Flowers—Pictorial works.
     I. Colette, 1873-1954. Essays.
     English. Selections. 1993. II. Title.
TR724.H45  1993
779'.34—dc20               92-28183
                           CIP

Distributed in Canada
by Raincoast Books,
112 East Third Avenue
Vancouver, B.C. V5T 1C8

10 9 8 7 6 5 4 3 2 1

Chronicle Books
275 Fifth Street
San Francisco, CA  94103

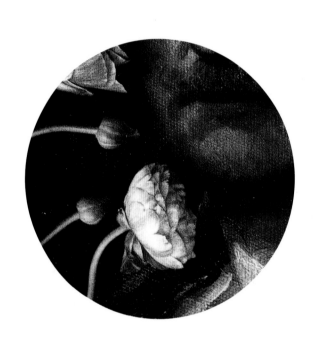